THE
PRIMARY SOURCE LIBRARY
OF
FAMOUS ARTISTS™

VINCENT VAN GOGH

Catherine Nichols

The Rosen Publishing Group's
PowerKids Press™
PRIMARY SOURCE

New York

In memory of my grandmother, Catherine Kane

Published in 2006 by The Rosen Publishing Group, Inc.
29 East 21st Street, New York, NY 10010

First Edition

Editor: Kathy Kuhtz Campbell
Book Design: Emily Muschinske
Photo Researcher: Sherri Liberman

Photo Credits: Cover (left) Rijksmuseum Vincent Van Gogh, Amsterdam, The Netherlands/Roger-Viollet, Paris/Bridgeman Art Library, (right) © Francis G. Mayer/CORBIS; p. 4 © Gianni Dagli Orti/CORBIS; pp. 6 (top and bottom), 7, 10, 14 © Yves Forestier/CORBIS SYGMA; p. 8 (top) Van Gogh Museum Foundation, Amsterdam/Vincent van Gogh Foundation, (bottom) © Hulton Archive/Getty Images; p. 12 (left) Private Collection/Bridgeman Art Library, (right) © Christie's Images/CORBIS; pp. 16, 22 (top), 24 Erich Lessing/Art Resource, NY; p. 18 Musée d'Orsay, Paris, France/Giraudon/Bridgeman Art Library; p. 19 Metropolitan Museum of Art, New York, USA/Bridgeman Art Library; p. 20 (top) © Gustavo Tomsich/CORBIS, (bottom) © Archivo Iconografico, S.A./CORBIS; p. 22 (bottom) © Christie's Images; p. 26 © Digital Image (c) The Museum of Modern Art/Licensed by SCALA/Art Resource, NY; p. 28 (top) © Francis G. Mayer/CORBIS, (bottom) Van Gogh Museum Foundation, Amsterdam/Vincent van Gogh Foundation.

Library of Congress Cataloging-in-Publication Data

Nichols, Catherine.
Vincent van Gogh / Catherine Nichols.— 1st ed.
 p. cm. — (The primary source library of famous artists)
Summary: Discusses the life, work, and legacy of nineteenth-century Dutch artist Vincent van Gogh.
Includes bibliographical references and index.
ISBN 1-4042-2766-0 (Library Binding)
1. Gogh, Vincent van, 1853–1890—Juvenile literature. 2. Painters—Netherlands—Biography—Juvenile literature. [1. Gogh, Vincent van, 1853–1890. 2. Painting, Dutch. 3. Painting, Modern—19th century.] I. Title. II. Series.
ND653.G7 N48 2005
759.9492—dc22

2003019426

Manufactured in the United States of America

Contents

1 The Little-Known Painter 5

2 A Talent for Art 7

3 Off to London 9

4 Helping the Penniless 11

5 Studying to Be an Artist 13

6 *The Potato Eaters* 15

7 Happy Times 17

8 The Crazy Redhead 19

9 The Yellow House 21

10 In Trouble 23

11 A Painting of Vincent 25

12 *The Starry Night* 27

13 Alone in a Field 29

Timeline 30

Glossary 31

Index 32

Primary Sources 32

Web Sites 32

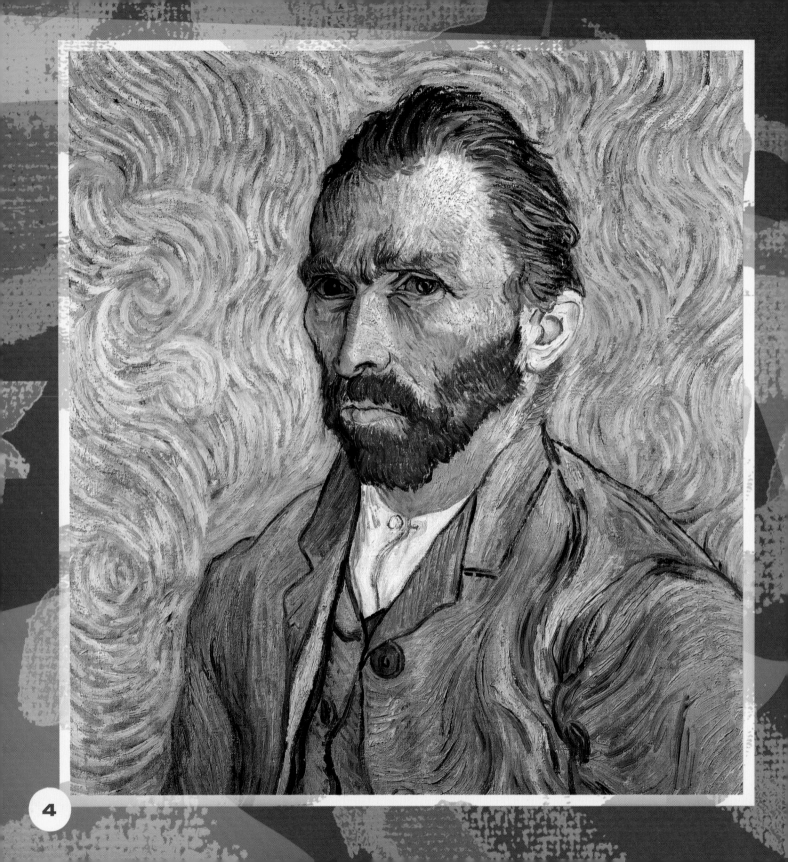

The Little-Known Painter

The Dutch painter Vincent van Gogh is one of the world's most popular artists. However, he sold only one painting while he was alive. That picture was *The Red Vineyard*, which sold for a small amount of money during an exhibition in Brussels, Belgium, in 1890. An exhibition is a public show of artworks. One hundred years later, Van Gogh's *Portrait of Dr. Paul Gachet* sold in New York for $82.5 million. This price was the highest price ever paid for a work of art at the time.

For most of his life, Van Gogh battled **mental illness** and being poor. Still, no matter how troubled he was, he continued to paint. He created a **style** that was all his own. It was not until after his death at the age of 37 that the world began to value his great talent.

Vincent van Gogh painted this picture of himself, called a self-portrait, in September 1889. At the time of this painting, he was receiving treatment at a mental hospital in Saint-Rémy, France.

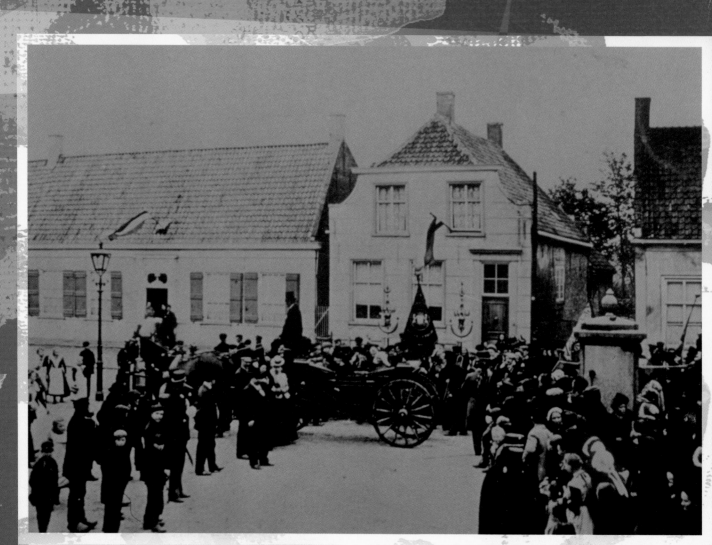

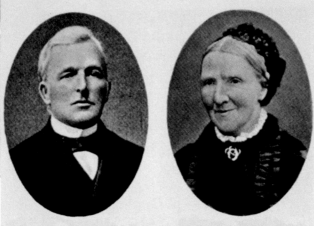

Above: The Van Gogh family lived in this house (center) in the town of Groot Zundert in the Netherlands. Vincent was born in the second-floor room with the flag hanging from the window.

Left: Vincent's father, Theodorus van Gogh, was a minister in the Dutch Reformed Church. Vincent's mother, Anna, cheerfully joined her husband on visits with church members.

A Talent for Art

Vincent van Gogh was born in Groot Zundert in the Netherlands on March 30, 1853. His father, Theodorus, was a **minister.** His mother, Anna, was a bookbinder's daughter. Vincent was their oldest child. He had three sisters and two brothers. He was closest to his brother Theo, who was four years younger. Theo remained his best friend for life.

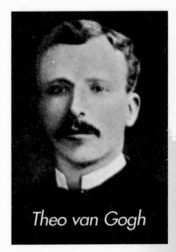

Theo van Gogh

Vincent went to the local school until 1864. Then Vincent was sent to live at a school in the town of Zevenbergen, which is 16 miles (25 km) north of Groot Zundert. He did well in school but was unhappy. He preferred drawing to schoolwork. After four years of schooling, he returned to Groot Zundert.

His interest in art might have come from his three uncles who were **art dealers**. At age 16, Vincent got his first job. He worked as a clerk in his uncle Cent's art **gallery**, Goupil & Company, in The Hague.

Left: Van Gogh made this drawing of Austin Friars Church in London sometime between July 1874 and May 1875. The church that Van Gogh drew and attended was ruined by bombs in 1940, during World War II.

Bottom: Van Gogh enjoyed visiting the National Gallery, shown here around 1870. In a letter to some friends written on August 7, 1873, he said, "I am not in a hurry to see everything. . . . I am quite satisfied with the museums, parks, etc.; they interest me more."

Off to London

Van Gogh did such a good job at Goupil's that, four years later, in 1873, he was sent to the company's office in London, England. Van Gogh liked London. He visited the city's galleries and museums, including the National Gallery. While in London, Van Gogh fell in love with a young woman. She did not return his feelings. Besides being upset by her not returning his feelings, he was troubled by all the poor people he saw in the city.

At the same time, he started to dislike working at Goupil's London office. In 1875, the company sent Van Gogh to their office in Paris, France. He was fired in early 1876 because he had left his job to go to the Netherlands at Christmas, which was the company's busiest time.

Art Smarts

In 1872, Van Gogh and his brother Theo started writing letters to each other regularly. This letter writing lasted all their lives. Van Gogh wrote about his life and art and often made drawings in the letters. In November 1878, he wrote to Theo, "How rich art is, if one can remember what one has seen, one is never without food for thought or truly lonely, never alone."

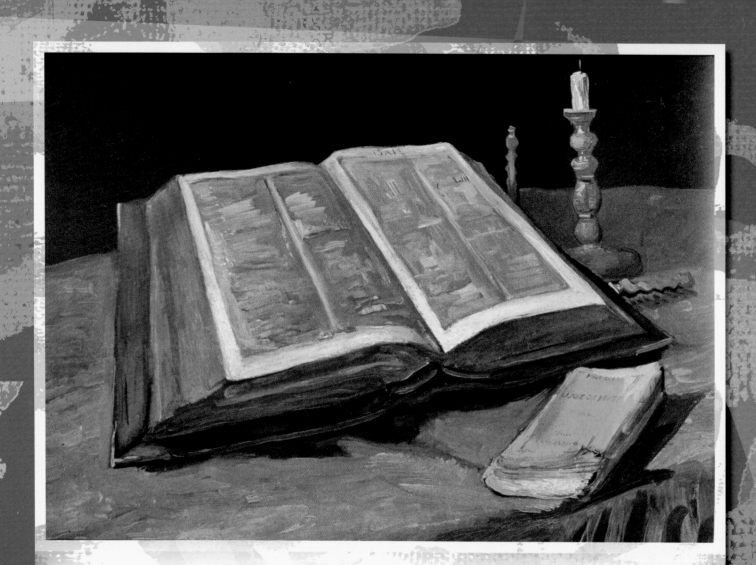

Van Gogh made this painting of his father's Bible in 1885. Van Gogh often questioned the purpose of his life. In 1876, he decided that he wanted to become a minister to help others. Van Gogh's father wanted Vincent to show how real his decision was by completing the necessary study. This meant that Van Gogh had to go to school for seven years and then take a state test. However, Van Gogh did not pass the tests to enroll in school. By the end of 1877, he had decided to study religion, or belief in God, on his own.

Helping the Penniless

Van Gogh returned to England in 1876 and worked as a teacher. At age 24, he decided to become a minister and help people. To become a minister, he had to attend school. Unfortunately he was unable to pass the tests to get into school, though he tried in both Amsterdam and Brussels.

Instead Van Gogh worked as a lay preacher. A lay preacher is a person who preaches, or gives talks, about God without special training. Van Gogh was sent to the Borinage, a coal-mining area in southern Belgium. The coal miners did not earn much money and had to work very hard. Van Gogh tried to help them by giving them money, his own clothes, and even his belongings. He wished to live like them. The people who had hired Van Gogh found him wearing rags and living in a miner's hut. They were not pleased about his actions, and they fired him in 1879.

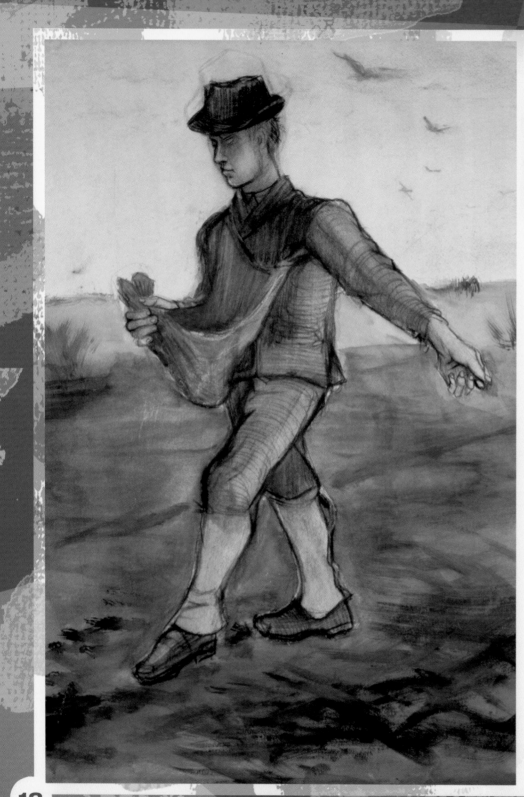

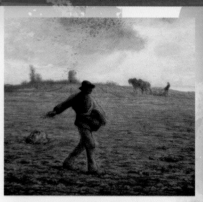

Above: Jean-François Millet painted this picture titled The Sower around 1850. A sower is a person who spreads seeds over the ground.

Left: Throughout Van Gogh's life, he drew and painted works based on Millet's painting The Sower. Van Gogh made this drawing called The Sower in pencil, pen, and brown ink in 1881. Some people believe that the subject stood for Van Gogh's early wish to be a preacher, a sower of God's word.

Studying to Be an Artist

Van Gogh had tried many jobs and had not succeeded in any of them. He had always been good at drawing. In 1880, after talking it over with Theo, Van Gogh decided to become an artist. Theo worked at Goupil's Paris office. He agreed to send Vincent money for living and for art supplies.

Theo sent Van Gogh money so that he could study art in Brussels. Van Gogh took lessons with Anthon van Rappard, a successful painter. Van Gogh learned how to draw the human body and studied the rules of **perspective**. He copied famous paintings, such as *The Sower* by Jean-François Millet. After finishing his lessons, Van Gogh returned to The Hague in 1881, where he studied with his cousin, the painter Anton Mauve.

Art Smarts

Van Gogh did not always sign his paintings. Only when he felt a painting was worthy did he write his name on it. He signed his work "Vincent" because he thought that his last name was too hard to say.

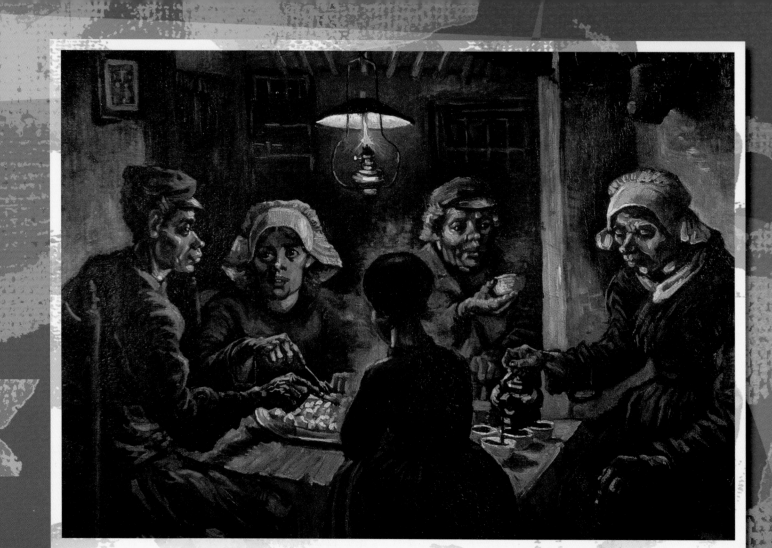

Van Gogh finished his oil painting The Potato Eaters in 1885. He studied the peasant potato farmers in the village of Nuenen. He painted them eating the potatoes that they had dug from the earth. Van Gogh wanted to show in his work that these poor peasants and their simple meal were worthy subjects to paint. He used mostly dark, earthy colors such as brown and black in the painting. The peasants look tired, and their hands are bumpy and dirty. People who saw his painting found it too dark and sad.

The Potato Eaters

In 1883, when Van Gogh was 30, he went to live with his parents in their new home in Nuenen, the Netherlands. There he drew pictures of **peasants** and other people who had to work hard to make a living.

Two years later Van Gogh's father, Theodorus, died. Although he was upset by his father's death, Van Gogh continued to work hard. He planned his first major painting, making many drawings and studies in oil of a group of people eating a simple meal around a table. The oil painting, finished in 1885, is titled *The Potato Eaters*.

Unlike many artists who painted pretty pictures of peasants, Van Gogh wanted to show how poor people really lived. He tried to show the peasants' feelings in his picture.

Art Smarts

Van Gogh began to use oil paints in 1882. Oil paints, made of colored powders and linseed oil, were expensive. Van Gogh often wrote to Theo to ask for more tubes of paint. He liked to apply the paint thickly, without thinning it first with turpentine as some artists did. The effect of thicker paint gave Van Gogh's paintings a sense of movement and feeling.

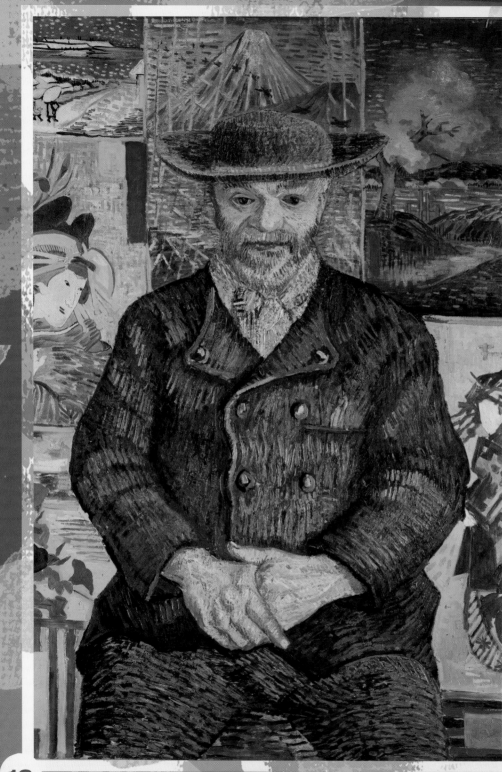

Van Gogh painted this picture of an art supply salesman named Julien Tanguy in 1887. Van Gogh and other artists called Tanguy Père, or Father, because he was always kind to them. He often let them trade their paintings for supplies. Note the many Japanese-style prints Van Gogh painted behind Tanguy. Van Gogh collected Japanese prints and often included images of his favorites in his own artworks.

Happy Times

Van Gogh entered the Antwerp Art Academy in 1886. He found the school's approach too **traditional** and soon left. He moved to Paris, which was then the center of the art world, and lived with Theo. Some of the artists with whom Theo worked as an art dealer were **Impressionists**. These artists painted quickly, using dabs of bright color to show the changing effects of light. Van Gogh met the artists Paul Cézanne, Claude Monet, Pierre-Auguste Renoir, Henri de Toulouse-Lautrec, and Paul Gauguin. He respected these painters and used some of their **techniques**. Van Gogh used brighter colors and a greater number of colors than he had before. Instead of painting gloomy peasants, he painted cheerful street scenes and **still lifes**.

Art Smarts

Van Gogh began to collect Japanese prints in Antwerp. Dishes and other breakable objects often arrived at the docks wrapped in prints made by Japanese artists. The Japanese artists chose subjects that showed everyday activities. They used bold colors. Van Gogh liked the prints' subjects and colors and tried to use these effects in his works.

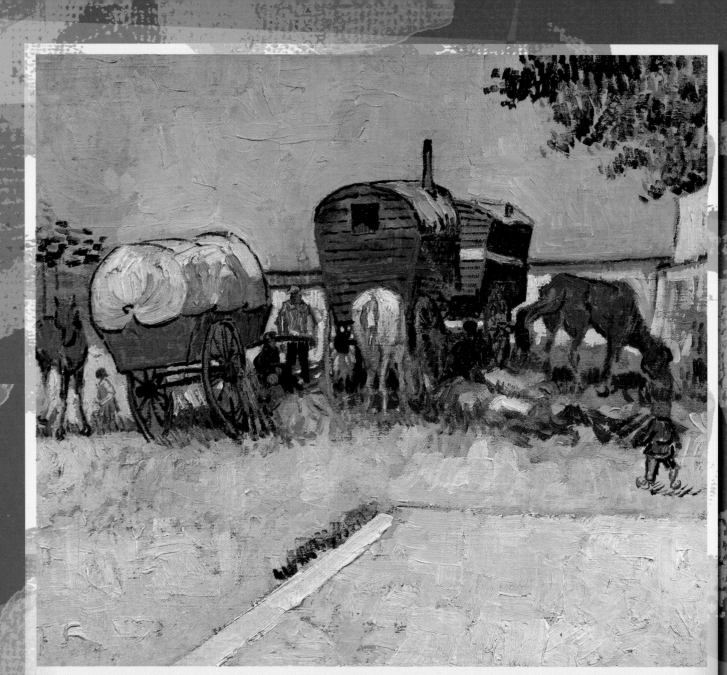

Van Gogh painted The Caravans, Gypsy Encampment near Arles *in 1888, the year he moved to Arles. Gypsies are people who belong to a group that came to Europe from India. They are often wanderers. Van Gogh painted them and their wagons using bright colors, but he used darker colors to outline the subjects, as did Japanese artists.*

The Crazy Redhead

After two years in Paris, Vincent van Gogh became worn out by the fast pace of the city. He was often ill, and he had become hard to live with.

In need of a change, he moved to Arles in the south of France, in a region called Provence. The countryside was sunny and beautiful. He painted in the fields of Arles often. After dark, he put candles on the edge of his hat so that he could continue to paint.

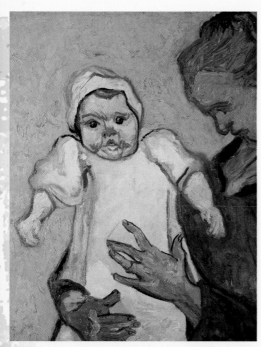

Van Gogh painted Madame Roulin and Her Baby *in 1888.*

The people of Arles did not know what to think of this wild-looking man. His face was sunburned from painting outside, and his clothes were messy. People began to call him the Crazy Redhead. Van Gogh did make one friend, however. Postal worker Joseph Roulin often invited Van Gogh to have dinner with Roulin's family.

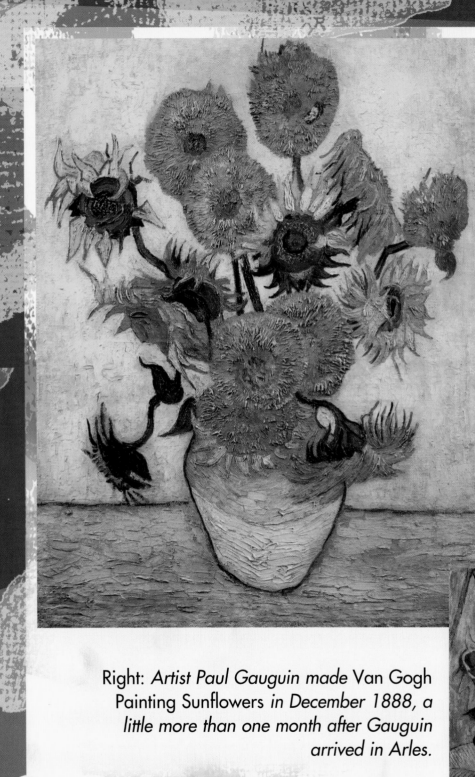

Left: *Van Gogh liked to paint sunflowers. Today about 11 of Van Gogh's sunflower paintings exist. These paintings are probably his best-known and best-loved works. He did this painting of 15 sunflowers in 1889.*

Right: *Artist Paul Gauguin made Van Gogh Painting Sunflowers in December 1888, a little more than one month after Gauguin arrived in Arles.*

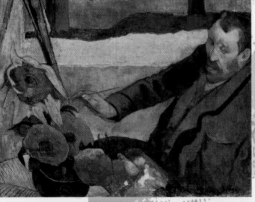

The Yellow House

When Van Gogh first arrived in Arles in February 1888, he stayed in an inn. Then he decided to rent four rooms in the Yellow House, which had been named for its color. He dreamed of turning the Yellow House into a place where artists could live and work. He invited Paul Gauguin to this "**studio** in the South."

The bright sun of Arles helped to give Van Gogh a lot of energy. Yellow became Van Gogh's favorite color. He painted golden cornfields, haystacks, and sunflowers. However, he worked so hard that he did not take care of his health. Sometimes he had **seizures** and fainted.

When Gauguin first arrived, the two men got along well. They were very different from each other, however. They did not agree on the best way to paint. Gauguin thought artists should paint from memory. Van Gogh thought they should paint what they saw. After a few weeks, they began to argue. Soon they fought regularly.

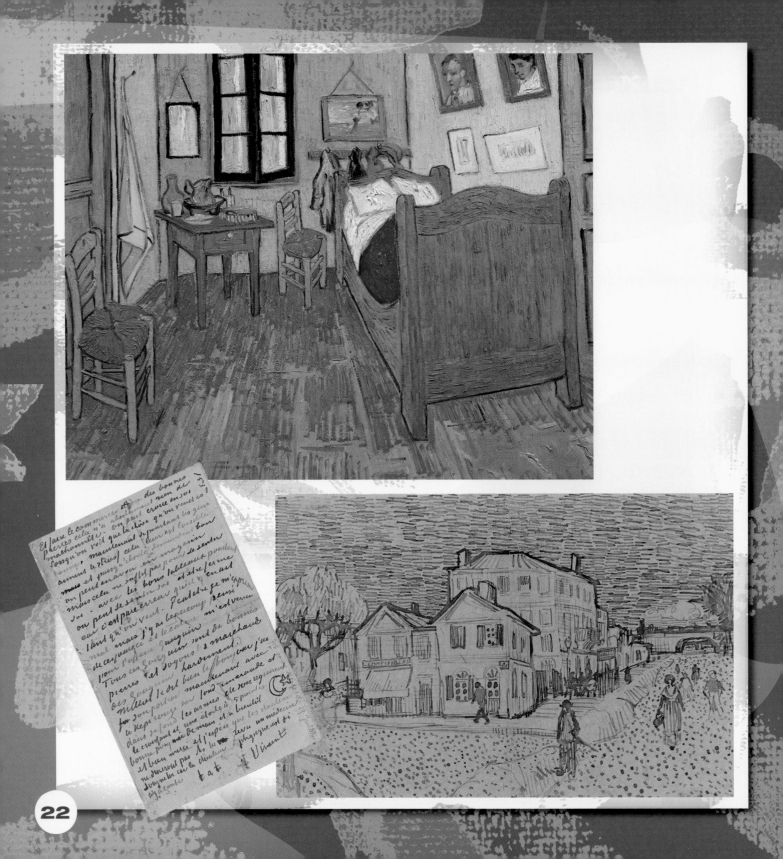

In Trouble

Living together did not become easier for Gauguin and Van Gogh. Their arguments only increased. Right before Christmas 1888, the two men had a terrible fight. Gauguin stormed out of the Yellow House and stayed at a boardinghouse for the night. Alone, Van Gogh became more upset. He took a blade and cut off part of his left ear. He wrapped it in paper and took it to a woman he knew nearby. After he left she called the police, who found Van Gogh lying in his bed. Because of his mental state and loss of blood, they could not wake him. The police took him to the hospital in Arles. Theo was sent for and he rushed to his brother's side. Theo sent for a minister, because he thought Vincent was dying. Vincent did not wake up for three days.

Top: *Van Gogh painted three different pictures of his bedroom in the Yellow House in Arles. He painted this work in 1889, which shows a picture of him hanging over the bed.* Bottom: *On the back of this letter* (left) *that Van Gogh wrote to Theo in September 1888, he drew the Yellow House. It is the corner house with window shutters.*

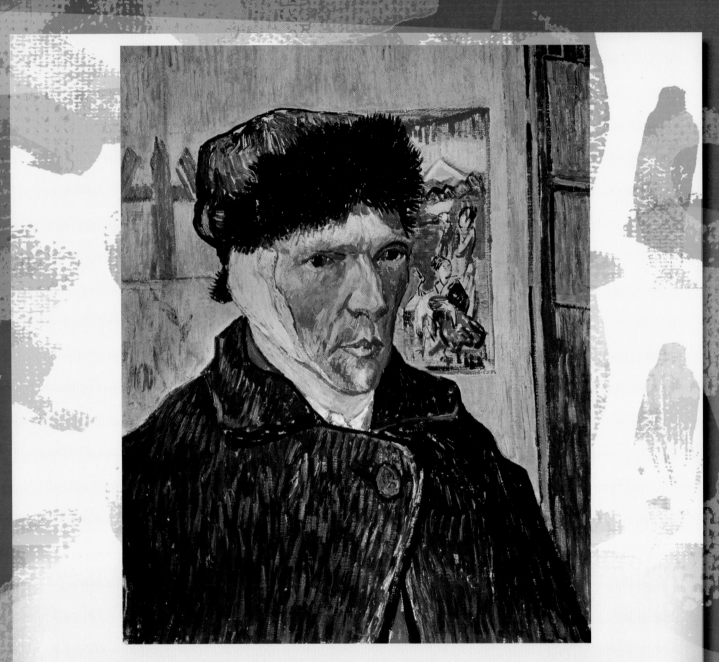

Van Gogh painted Self-Portrait with Bandaged Ear *in early January 1889. He left the hospital on January 7 and soon set to work on this painting. He made one other picture showing his ear bandaged. In both paintings he is seen wearing a fur hat and a coat. In this picture Van Gogh included his easel, or the stand that holds a painting, and a Japanese print in the distance.*

A Painting of Vincent

In January 1889, Van Gogh left the hospital and returned to the Yellow House. Gauguin had left Arles. In spite of his recent illness, Van Gogh went back to work. He painted a **self-portrait** showing his bandaged ear, and a portrait of Doctor Félix Rey, who had taken care of him in the hospital. By the end of February 1889, Van Gogh had two more **breakdowns**. The townspeople were afraid of Van Gogh. They asked the town leader to put him in the hospital for good. The police took him back to the hospital, where he stayed for about a month. When he returned to the Yellow House, he found that his rooms had been rented to someone else. He packed his paintings and sent them to Theo. He decided to live at the hospital until he felt well.

Art Smarts

From 1885 to 1889, Van Gogh painted more than 40 self-portraits. In some he appears cheerful, and in others he looks gloomy. In January 1889, less than a month after he cut off part of his left ear, he made several self-portraits. In these artworks, it looks as if his right ear was the one that was hurt. He used a mirror while painting, so the picture shows an opposite view.

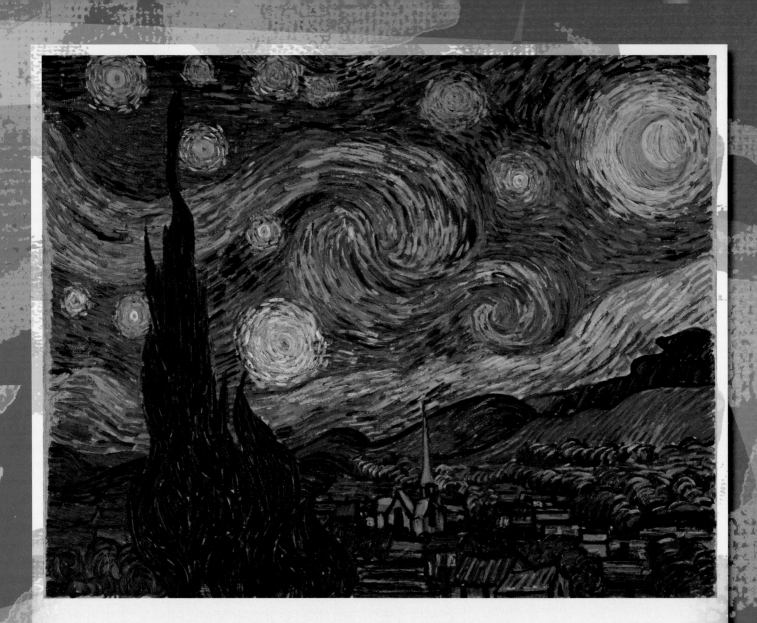

Van Gogh painted The Starry Night *from his room in the hospital in Saint-Rémy in June 1889. He showed the roofs of the houses and the church and the distant mountains. He painted the trees, called cypresses, and the shining stars in such a way that they seem to move and to spin with great energy.*

The Starry Night

Van Gogh had a hard time returning to his daily activities in Arles. He went to an asylum, a special hospital, for care in the nearby town of Saint-Rémy. As he slowly got better, he began to draw and paint again. His doctor gave Van Gogh a room to use as a studio.

While he was at the asylum, Van Gogh produced one of his greatest paintings, *The Starry Night.* It is not only a powerful painting of the night sky, but also a true record of the position of the stars in June 1889.

By May 1890, Van Gogh was well enough to leave the asylum. He visited Theo in Paris for three days. Theo and his wife, Johanna, had a three-and-a-half-month-old son. The boy was named Vincent in honor of the artist.

After Van Gogh's brief visit, he went to live in Auvers-sur-Oise, a village north of Paris. He was put under the care of Paul Gachet, a **homeopathic** doctor. Gachet was also an art lover, and he and Van Gogh became friends.

Above: *In July 1890, Van Gogh spent many days painting in the wheat fields of Auvers-sur-Oise. He made this painting, titled* Wheat Field with Crows, *during one of his trips.*

Left: *This letter, dated July 24, 1890, is the last one that Van Gogh wrote to Theo. He wrote, "Well, the truth is, we can only make our pictures speak. . . . I have risked my life for my work, and it has cost me half my reason. . . ." The word "reason" means the ability to think clearly.*

Alone in a Field

Theo still sent Van Gogh money monthly. Van Gogh was unhappy that he needed money from Theo. In July 1890, he visited Theo in Paris and learned that Theo planned to return to the Netherlands. Van Gogh did not like the idea that his brother would live so far away.

Through all his troubles, Van Gogh found strength in painting. *Wheat Field with Crows*, one of his last works, was painted just days before his death. It shows the nervous state of his mind. He used dark colors and thicker paint than usual, making quick, almost wild brushstrokes.

In July, Van Gogh could bear his pain no longer. He shot himself in a field, walked home, and fell into bed. His landlord found him and sent for a doctor and for Theo. The doctor could not remove the bullet. Theo stayed at Vincent's side until he died two days later on July 29, 1890. Six months later, Theo died from an illness. He was buried next to Vincent in Auvers-sur-Oise.

Timeline

1853	Vincent van Gogh is born in Groot Zundert, the Netherlands, on March 30.
1864	Vincent goes to a school in Zevenbergen, the Netherlands.
1869	He works in The Hague, the Netherlands, as a clerk for Goupil & Company.
1873	He moves to London, England.
1875	Van Gogh moves to Paris, France.
1876	He is fired by Goupil & Company.
1877	He studies to be a minister but cannot pass the tests for enrolling in school.
1878	He preaches and lives in the Borinage, Belgium.
1879	He is fired as a lay preacher.
1880	Van Gogh moves to Brussels, Belgium. He studies to be an artist.
1881	He studies with painter Anton Mauve in The Hague.
1885	Van Gogh paints *The Potato Eaters*.
1886	He moves to Paris.
1888	Van Gogh moves to Arles, France. He produces a group of sunflower paintings. He cuts off part of his left ear.
1889	He enters the asylum at Saint-Rémy, France, for care. He paints *The Starry Night*.
1890	His painting *The Red Vineyard* sells for 400 francs in March. Vincent van Gogh dies in Auvers-sur-Oise, France, on July 29.

Glossary

art dealers (ART DEE-lurz) People who buy and sell pieces of art.

breakdowns (BRAYK-downz) Illnesses of the mind that happen when a person worries too much or becomes sad all the time.

gallery (GA-luh-ree) A room or building that shows works of art.

homeopathic (hoh-mee-uh-PA-thik) Having to do with treating an illness with small doses of plant or mineral matter to produce the same signs as the illness, causing the body to fight the illness naturally.

Impressionists (im-PREH-shuh-nists) Artists who follow Impressionism, a style of painting started in France in the 1860s. These artists tried to paint their subjects showing the effects of sunlight on things at different times of the day and in different seasons.

mental illness (MEN-tul IL-nes) A condition of being unwell in the mind.

minister (MIH-nih-ster) A person who has the authority to lead meetings of faith in a Protestant church.

peasants (PEH-zents) People who farm a small area of land.

perspective (per-SPEK-tiv) The way objects are shown in relation to each other in a work of art; distant objects are made smaller than nearer ones.

seizures (SEE-zherz) Sudden bursts of extra brain messages that cause odd brain activity and can cause the body to jerk.

self-portrait (self-POR-tret) A picture, often a painting, done by the artist of himself or herself.

still lifes (STIL LYFS) Pictures of objects that are often carefully arranged by the artist.

studio (STOO-dee-oh) A room or a building where an artist works.

style (STYL) A certain manner or method in which an artwork is made.

techniques (tek-NEEKS) Methods or ways of bringing about a wanted result in a science, an art, a sport, or a profession.

traditional (truh-DIH-shuh-nul) Used to doing things in a way that has been passed down over time.

Index

A

Amsterdam, the
 Netherlands, 11
Antwerp Art Academy, 17
Arles, France, 19, 21,
 23, 25, 27
Auvers-sur-Oise, France,
 27, 29

B

Borinage, the
 Netherlands, 11
Brussels, Belgium, 5, 11,
 13

C

Cézanne, Paul, 17

G

Gachet, Doctor Paul, 27
Gauguin, Paul, 17, 21,
 23, 25
van Gogh, Anna (mother),
 7
van Gogh, Theo (brother),
 7, 13, 17, 23,
 25, 27, 29
van Gogh, Theodorus
 (father), 7, 15
Goupil & Company, 7,
 9, 13
Groot Zundert, the
 Netherlands, 7

H

Hague, The, the
 Netherlands, 7,
 13

M

Mauve, Anton, 13
Millet, Jean-François, 13
Monet, Claude, 17

N

Nuenen, the Netherlands,
 15

P

Paris, France, 9, 13, 17,
 19, 27, 29
*Portrait of Dr. Paul
 Gachet*, 5
Potato Eaters, The, 15

R

Red Vineyard, The, 5
Renoir, Pierre-Auguste, 17
Rey, Doctor Félix, 25
Roulin, Joseph, 19

S

Saint-Rémy, France, 27
Sower, The, 13
Starry Night, The, 27

W

Wheat Field with Crows,
 29

Y

Yellow House, 21, 23,
 25

Primary Sources

Cover. Left. *Irises*, by Vincent van Gogh, 1890. The artist painted this still life while he was in the hospital of Saint-Rémy. It is one of Van Gogh's best-known floral paintings. Rijksmuseum Vincent van Gogh, Amsterdam, the Netherlands. **Page 4.** *Self-Portrait*, by Van Gogh, painted in Saint-Rémy in September 1889. Van Gogh painted about 40 self-portraits during his life. Musée d'Orsay, Paris, France. **Page 6. Top.** The House of Vincent van Gogh. Photo taken by Yves Forestier around 1900, in Groot Zundert, the Netherlands. **Bottom.** Portraits of the Van Gogh family. Theodorus van Gogh (left), Vincent's father, and Anna Cornelia Carbentus van Gogh (right), Vincent's mother. Photos taken by Yves Forestier, late 1800s. **Page 7.** Theo van Gogh, Vincent's younger brother. Photo taken by Yves Forestier in the late 1800s. **Page 8. Bottom.** The National Gallery, London, England. This photo was taken around 1870 and shows the Trafalgar Square entrance to the art museum, which Van Gogh visited. **Page 10.** *Still Life with Bible and Zola's "Joie de vivre"*, which was painted by Van Gogh in October 1885, shows Van Gogh's father's Bible. Van Gogh Museum, Amsterdam. **Page 12. Left.** *The Sower*, drawing by Van Gogh, 1881. Pencil, pen, and brown ink, after Jean-François Millet's painting, *The Sower*. Private Collection. **Right.** *The Sower*, painted by Jean-François Millet, about 1850. Christie's. **Page 18.** *The Caravans, Gypsy Encampment near Arles*, oil on canvas, painted by Van Gogh in 1888. Musée d'Orsay, Paris. **Page 19.** *Madame Roulin and Her Baby*, painted by Van Gogh in December 1888. Van Gogh became good friends with Joseph Roulin and his wife, Augustine, during his stay in Arles. **Page 20. Top.** *Sunflowers*, painted by Van Gogh in 1889. Sompo Japan Museum of Art, Tokyo. **Bottom.** *Van Gogh Painting Sunflowers*, oil on canvas, by Paul Gauguin, 1888. Sometimes called *The Painter of Sunflowers*, Gauguin painted this work while he was living with Van Gogh in the Yellow House. Van Gogh Museum, Amsterdam. **Page 22. Top.** *Vincent's Bedroom in Arles*, painted by Van Gogh in 1889. Musée d'Orsay, Paris. **Bottom.** *The Yellow House*, a drawing on the recto of a letter from Vincent to his brother Theo, September 1888. The verso is the letter with Vincent's signature. Christie's Images Limited. **Page 24.** *Self-Portrait with Bandaged Ear*, painted by Van Gogh in January 1889. He used a mirror to paint this image of his left ear injury. Courtauld Institute Galleries, London, England. **Page 28. Top.** *Wheat Field with Crows* was painted by Van Gogh in July 1890 during the month of his death. Van Gogh Museum, Amsterdam. **Bottom.** Vincent van Gogh's last letter to Theo, dated July 24, 1890. Theo wrote on the letter "Letter found on him on July 29." Jo, Theo's wife, had written a note about the letter, explaining that it was the last letter Van Gogh wrote to Theo. Van Gogh Museum, Amsterdam.

Web Sites

Due to the changing nature of Internet links, PowerKids Press has developed an online list of Web sites related to the subject of this book. This site is updated regularly. Please use this link to access the list:
www.powerkidslinks.com/psla/vangogh/